Moroccan Motifs

Coloring for Everyone

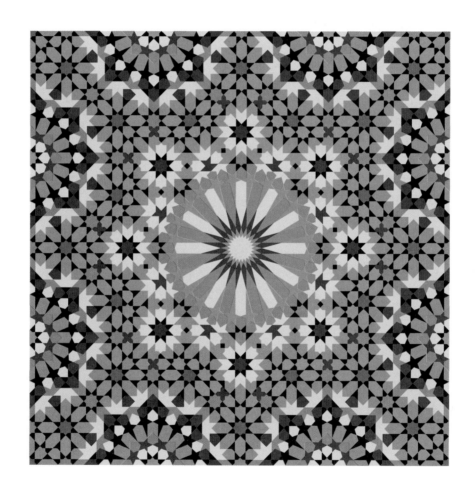

Skyhorse Publishing

T0040211

Artwork copyright © 2016:
iStock/José Antonio Sánchez Poy (Intro image: girih design)
iStock/Juan García Aunión (Intro image: wall at Ben Youssef Madrasa)
iStock/aury1979 (Intro image: zellige wall in Marrakesh)
Shutterstock/lizabarbiza (Intro image: mosaic lamps)
Shutterstock/Azat1976 (Images 1, 3–7, 9–31)
Shutterstock/paulrommer (Image 2)
Shutterstock/Arak Rattanawijittakorn (Images 8, 35)
Shutterstock/freesoulproduction (Image 32)
Shutterstock/ellina-ellka (Image 33)
Shutterstock/Marchenko Oleksandr (Image 34)
Shutterstock/Piranjya (Images 36, 39–41, 43–45)
Shutterstock/Lucky Team Studio (Image 37)
Shutterstock/Guu (Image 38)
Shutterstock/LauraKick (Image 42)
Shutterstock/Kseniavasil (Image 46)

Skyhorse Publishing books may be purchased in bulk at special discounts for sales promotion, corporate gifts, fund-raising, or educational purposes. Special editions can also be created to specifications. For details, contact the Special Sales Department, Skyhorse Publishing, 307 West 36th Street, 11th Floor, New York, NY 10018 or info@skyhorsepublishing.com.

Skyhorse® and Skyhorse Publishing® are registered trademarks of Skyhorse Publishing, Inc.®, a Delaware corporation.

Visit our website at www.skyhorsepublishing.com.

10 9 8 7 6 5 4 3 2 1

Cover design by Jane Sheppard
Cover artwork credit: Shutterstock/Azat1976
Text by Chamois S. Holschuh

Print ISBN: 978-1-5107-1450-2

Printed in the United States of America

Moroccan Motifs:
Coloring for Everyone

Typified by impressive mosaics and sweeping arabesques, Moroccan art is one of the most readily recognizable styles associated with a nation. Located in northwest Africa and featuring coasts on both the Atlantic and the Mediterranean, Morocco's unique geographic position made it a contested region of political significance as well as a meeting place of cultures and art forms. The various groups which have called the land home contributed their architectural methods, religious iconography, and various design motifs. The ancient Berbers' mud bricks, Islamic mosques and fountains, Spanish tiles, Moorish arches, and the French emphasis on courtyards and gardens—all of these have melded together to create what we now recognize as a distinct "Moroccan" style.

This adult coloring book is inspired by elements of this unique aesthetic, playing on the intricate knots of *girih* patterns and minute details of *zellige* tilework. As you'll see throughout these pages, girih is a mesmerizing art form consisting of symmetrical shapes and lines, intersecting and radiating from each other in a dazzling display of geometric precision. Often star-shaped, the "straps" weave together in a complex knot. Likely originating from Syrian knotwork patterns, these designs were adopted and recreated by Islamic cultures who brought the art form to Morocco. Girih can be found throughout Islamic countries, adorning mosques, window screens, and tapestries. Zellige, on the other hand, is more visible in Morocco than in any other locale. This eye-catching art form makes use of tiny, colored tiles, set in plaster, to create geometric mosaic patterns. Zellige became popular among Islamic artists as a decorative form because it lacked the depiction of living things (such as

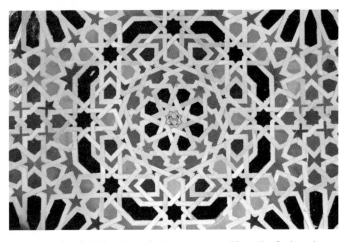

An example of girih. Note the intertwining "knot" of white lines, interspersed with colorful tiles in a symmetrical pattern.

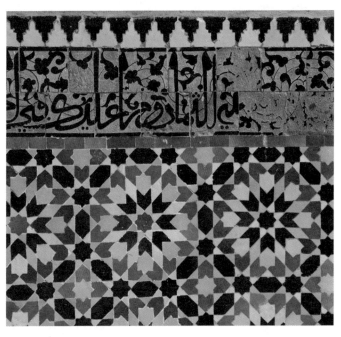

Detail from a *zellige* wall at the Ben Youssef Madrasa in Marrakesh, Morocco—an Islamic college named after the sultan Ali ibn Yusuf who made significant contributions to the city's growth and influence.

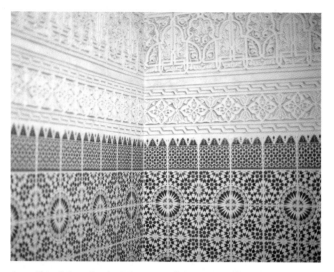
A wall in Marrakesh, Morocco, featuring zellige designs.

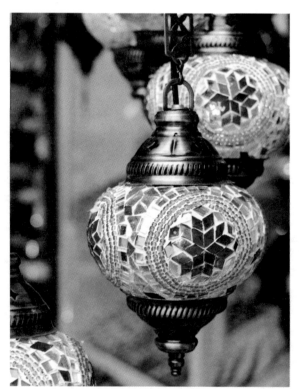
Mosaic lamps in the marketplace.

humans and animals)—subjects to be avoided according to Islamic law. The artists of Morocco developed an unrivaled talent for creating zellige by innovating various geometric designs and broadening the traditional palette to include blue, green, and yellow in the fourteenth century and eventually red in the seventeenth century. The detailed handiwork of zellige can be found on walls, floors, ceilings, tables, pools, and fountains throughout the country. Floral motifs are a common feature in the region's artwork as well, whether they're incorporated into girih designs, the inspiration behind a zellige burst pattern, or scrolling around the quintessential Moroccan archway. You'll find all of these beautiful patterns in this unique coloring book, and to mix things up a bit, we've also included a few not-so-Moroccan mosaics.

You'll find yourself transported as you peruse the stunning designs on these pages. Close your eyes, picture yourself touring the finest zellige works in Fez, and return to the comfort of your own home, invigorated and ready to color. Use the color bars at the back of the book to plan your palette or refer to the pre-colored versions of each design at the front of the book for a little inspiration. The pages are perforated, so you can remove them for a more comfortable coloring experience and put them on display when you're finished. Whatever your approach, we hope you'll use this coloring book as a creative tool for stress-relief and relaxation. Gather your colored pencils or markers, and prepare for an inspired journey into the heart of Moroccan art.

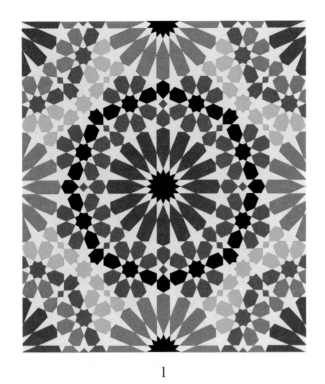

1

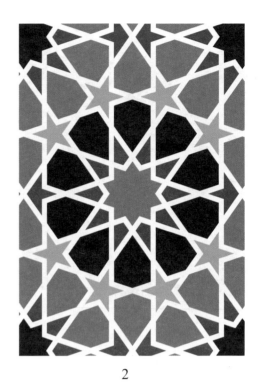

2

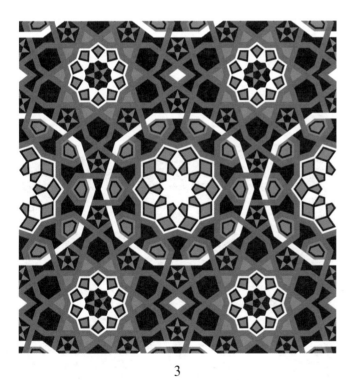

3

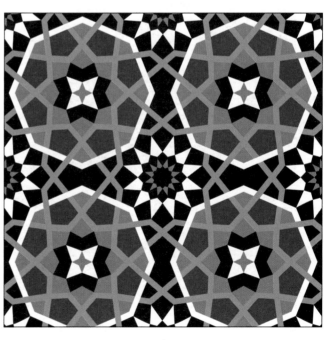

4

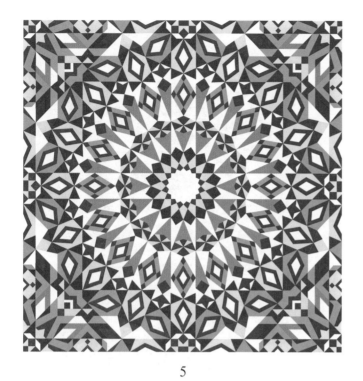

5

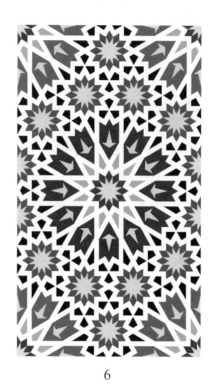

6

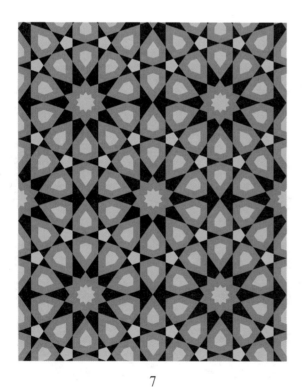

7

8

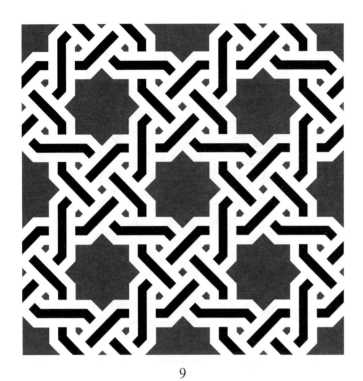

9

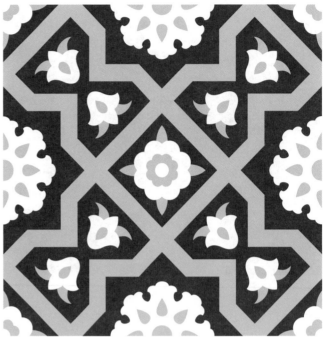

10

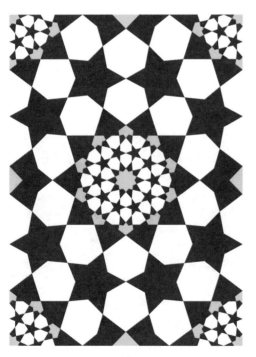

11

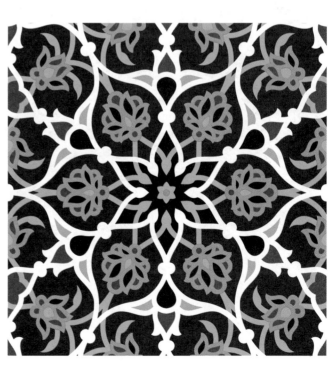

12

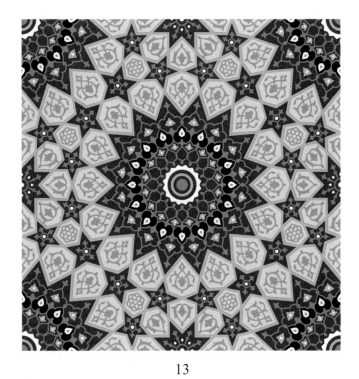

13

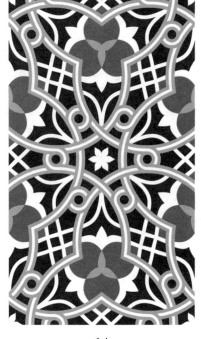

14

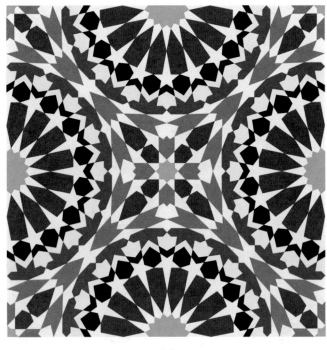

15

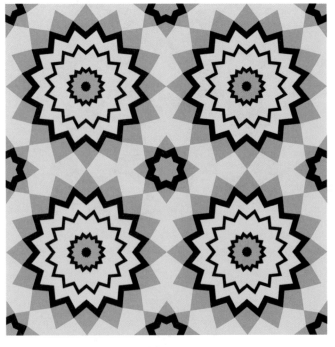

16

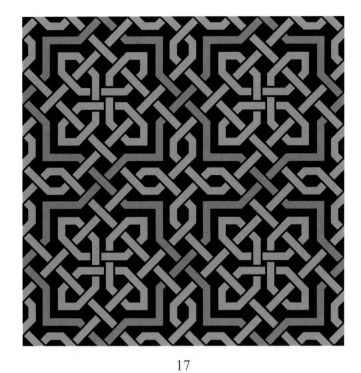

17

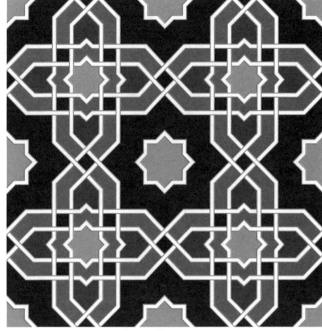

18

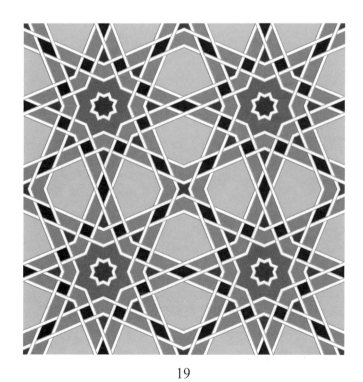

19

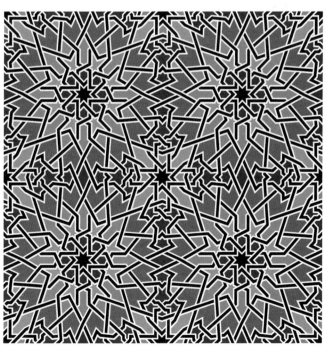

20

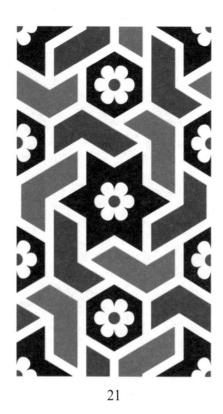

21

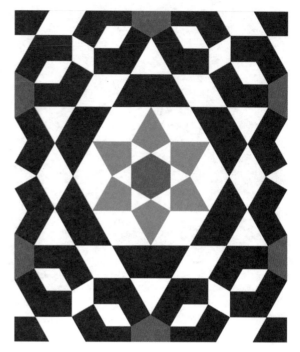

22

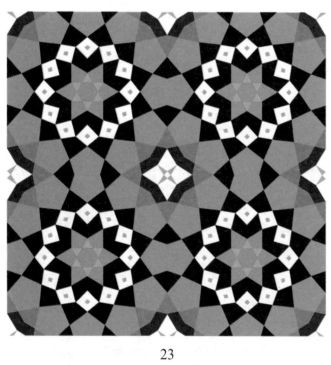

23

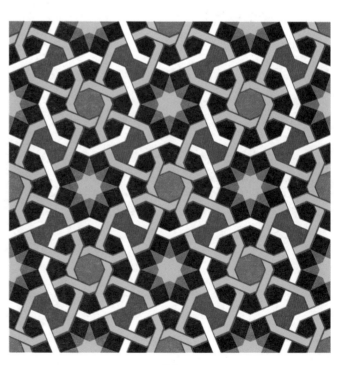

24

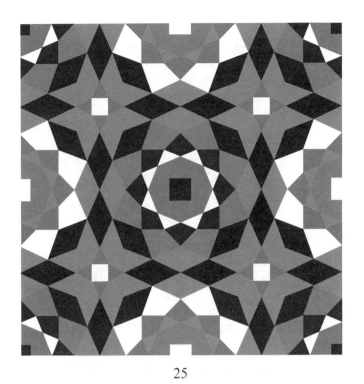

25

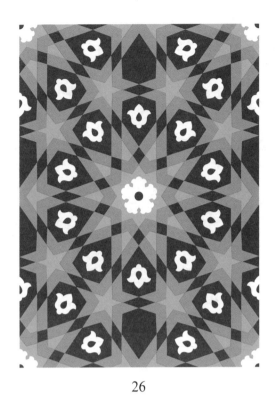

26

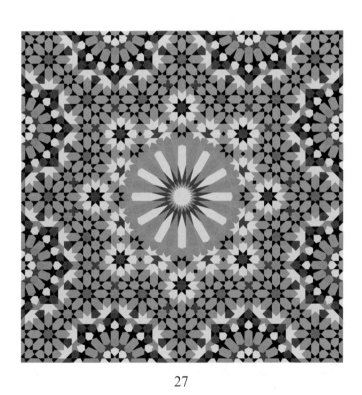

27

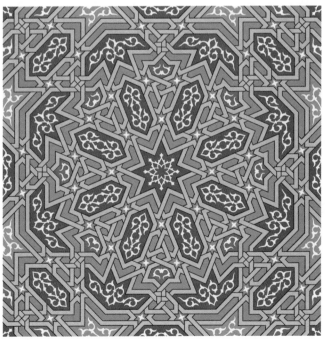

28

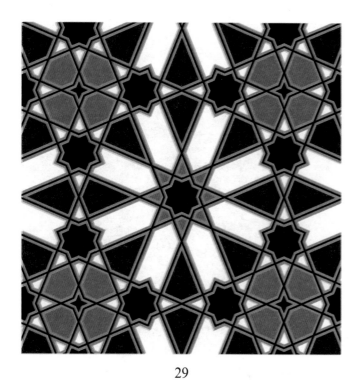

29

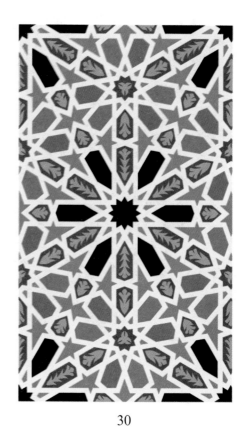

30

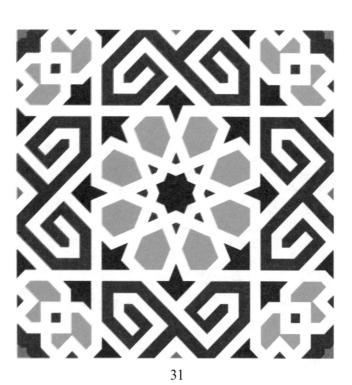

31

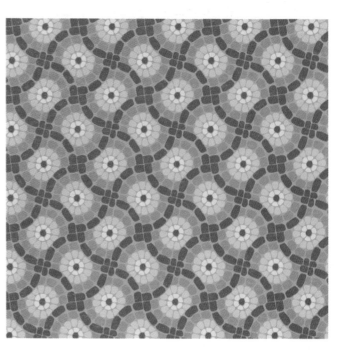

32

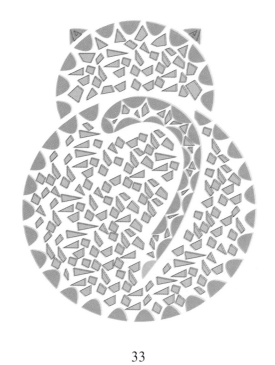

33

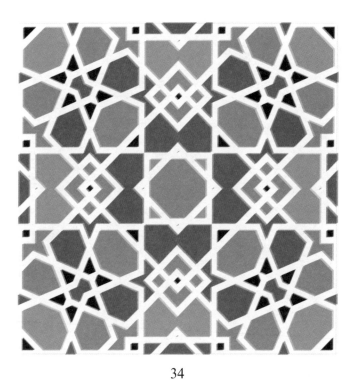

34

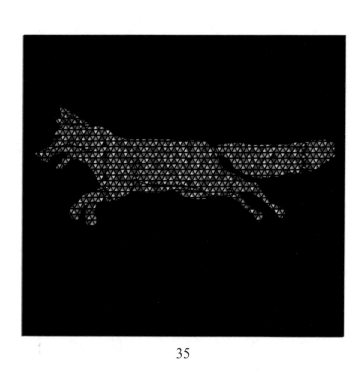

35

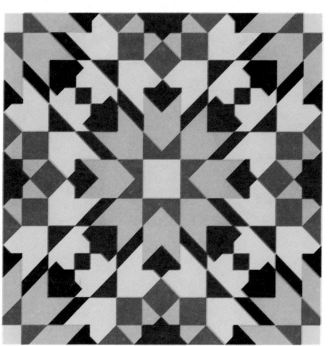

36

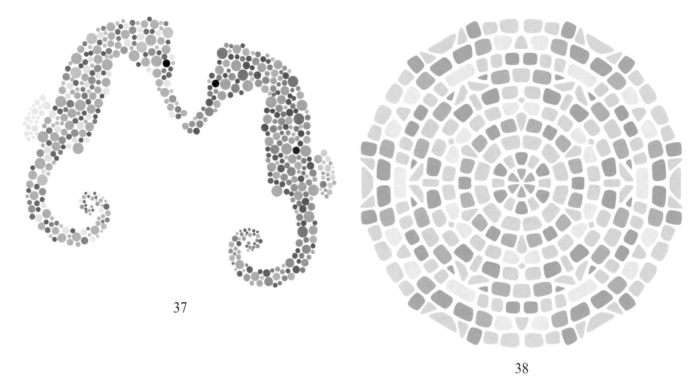

37

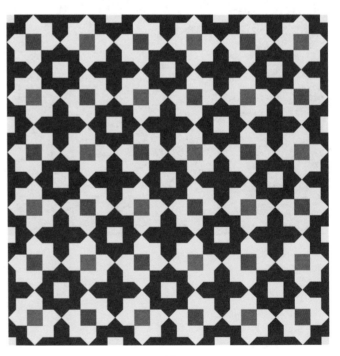

38

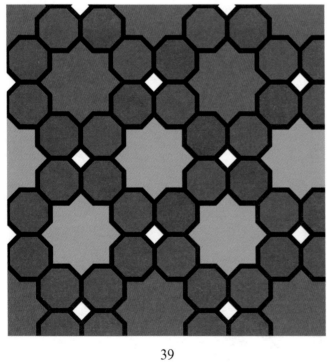

39

40

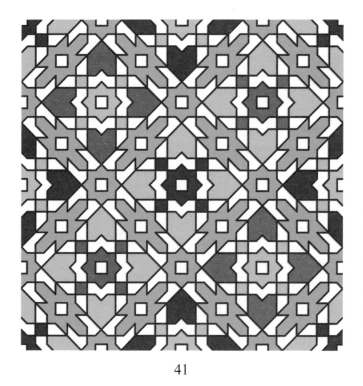

41

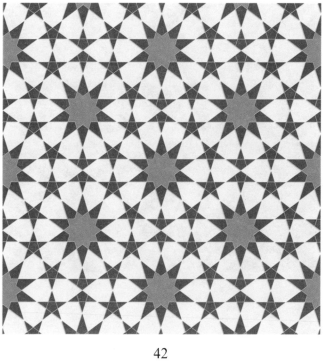

42

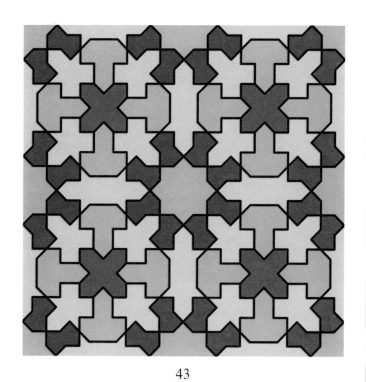

43

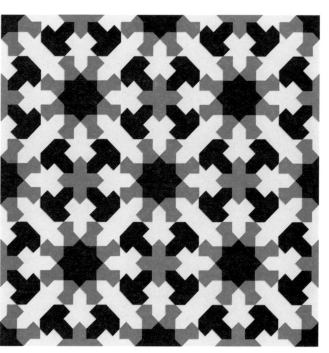

44

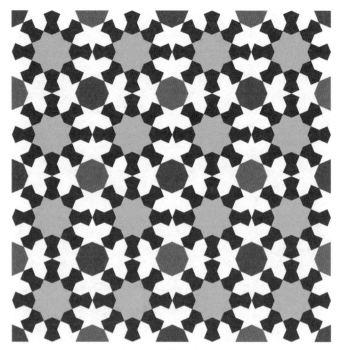

45

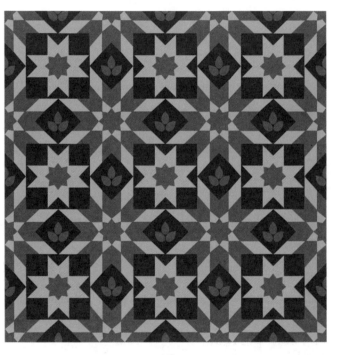

46

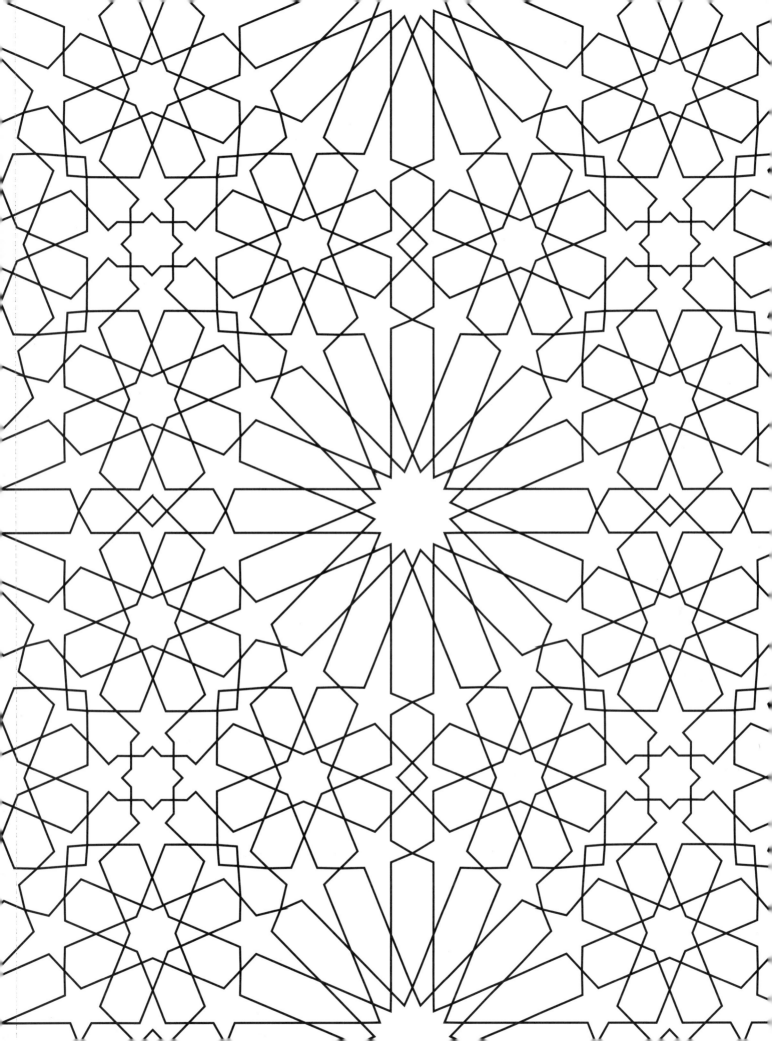

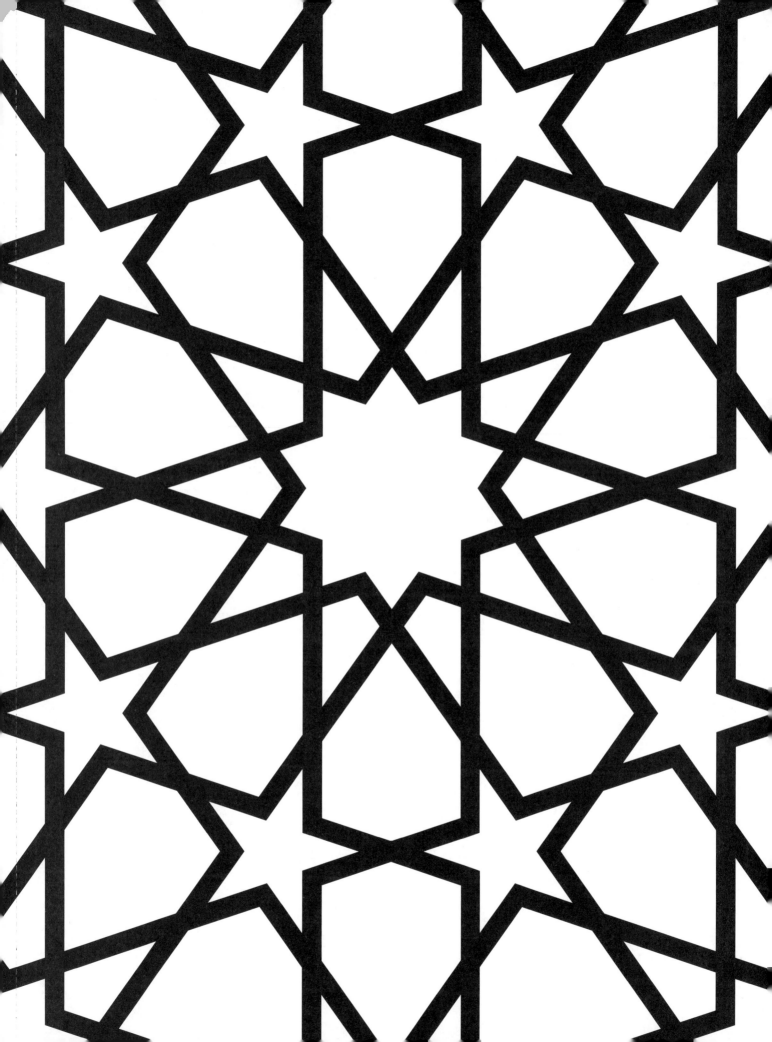

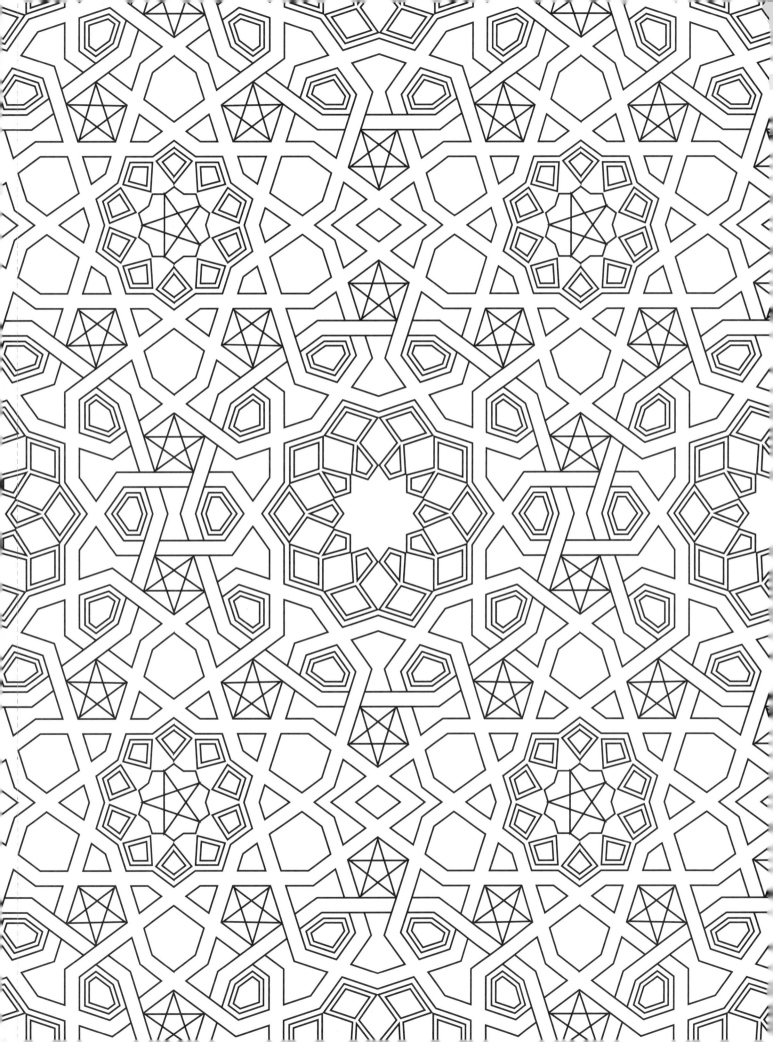

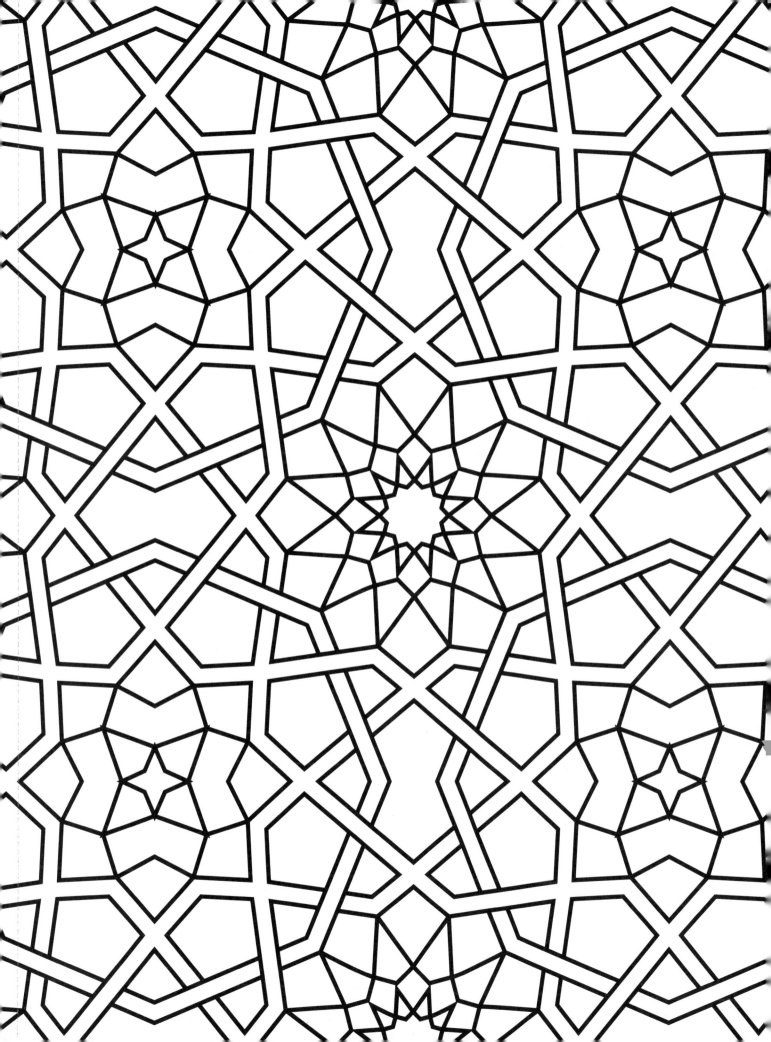

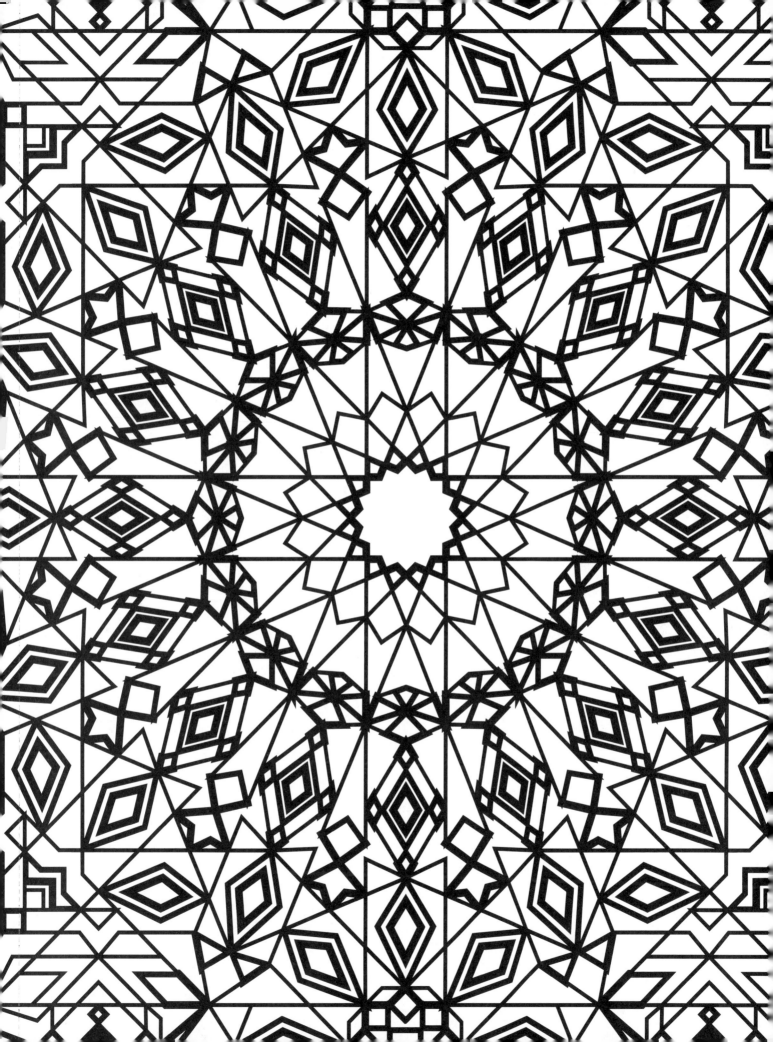

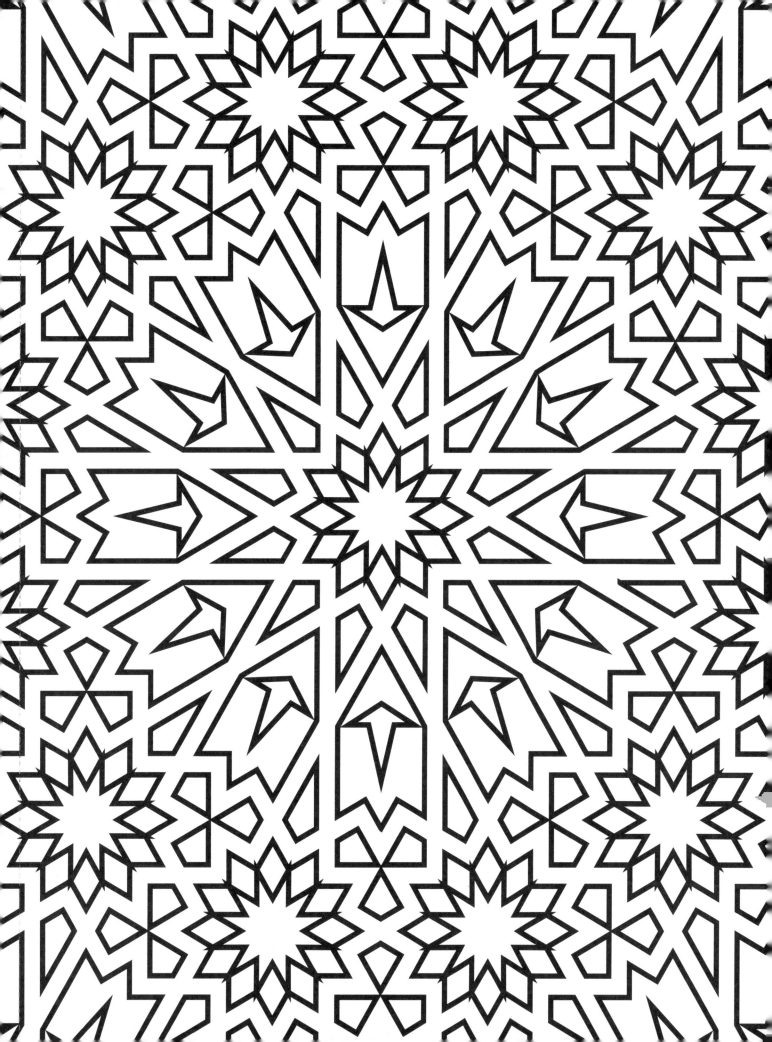

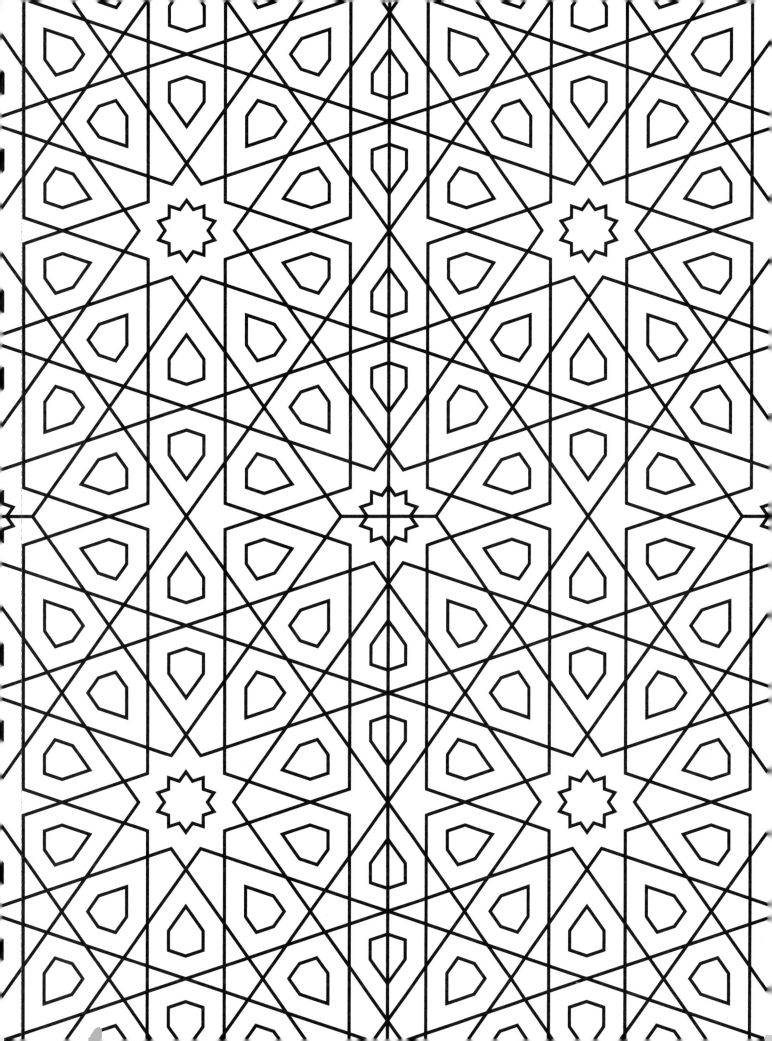

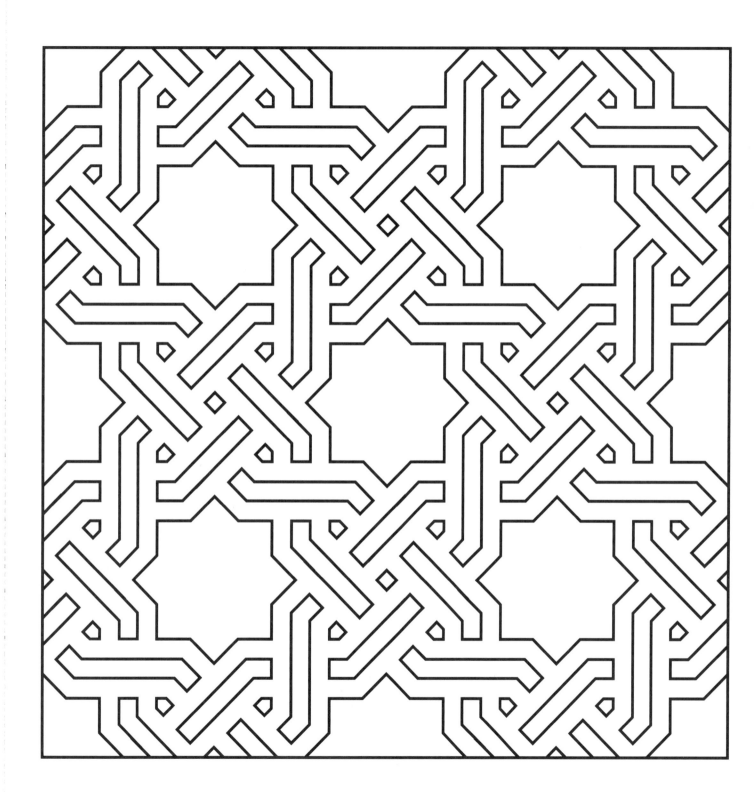

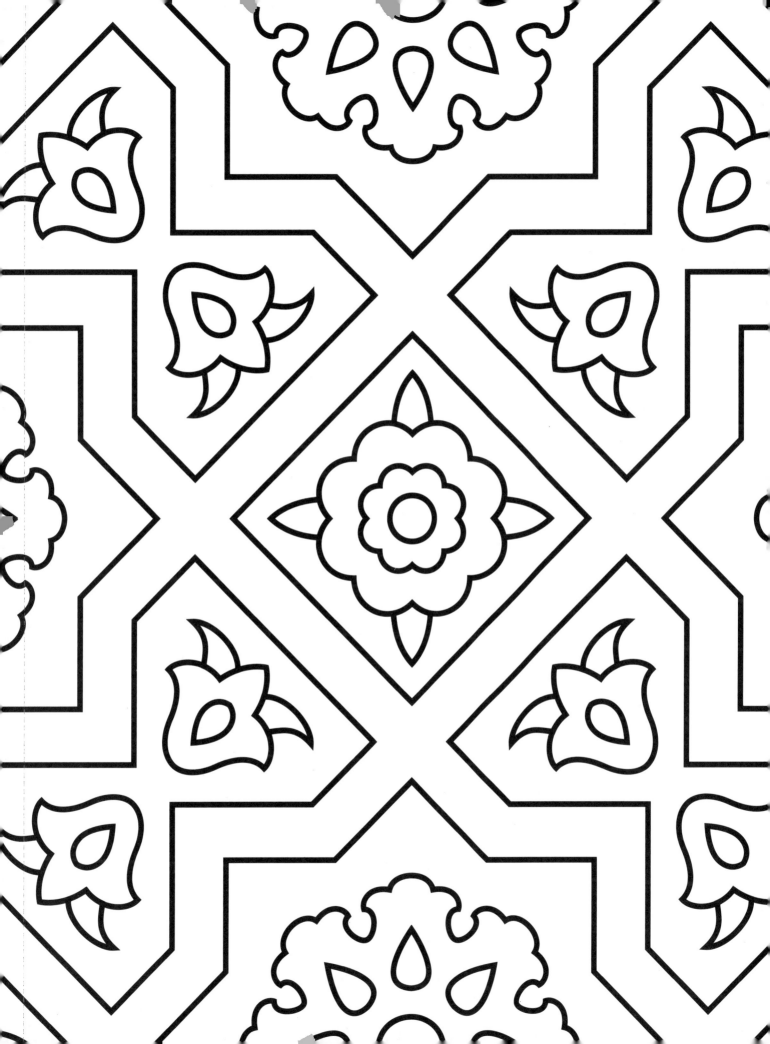

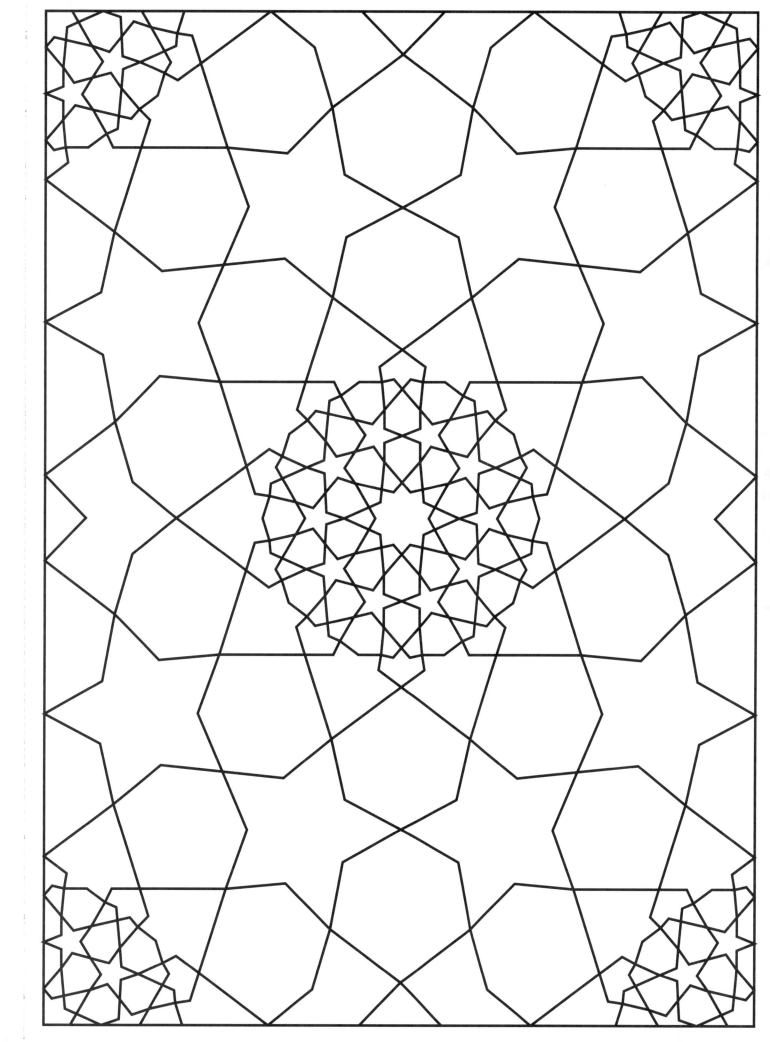

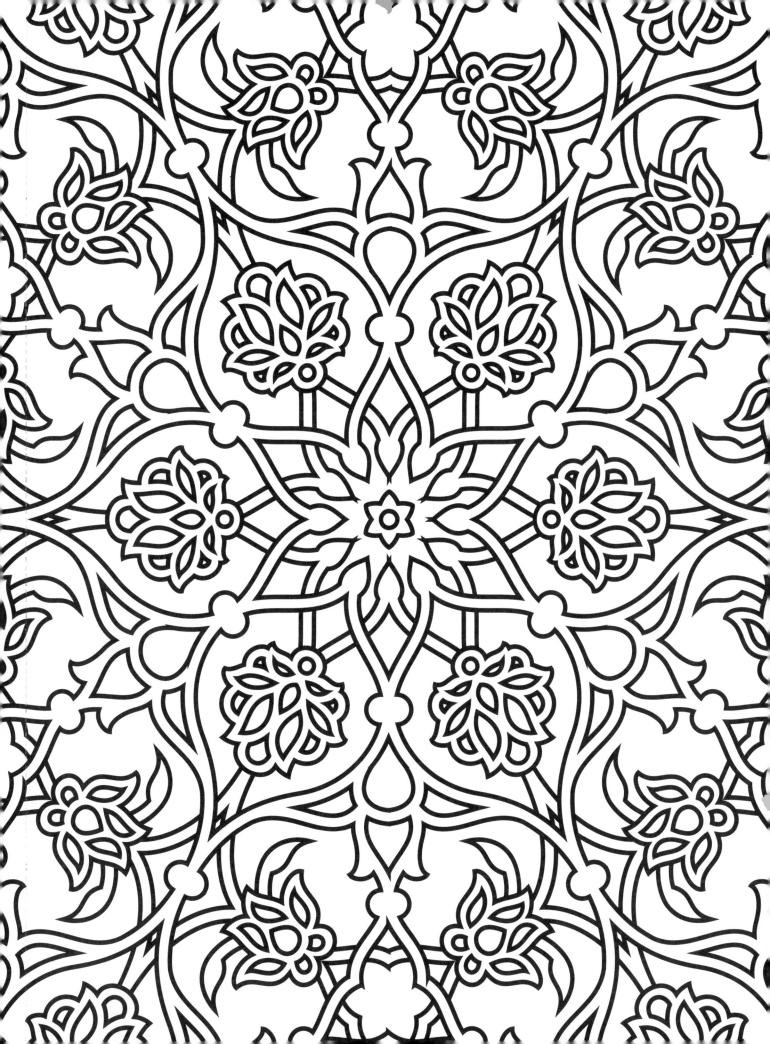

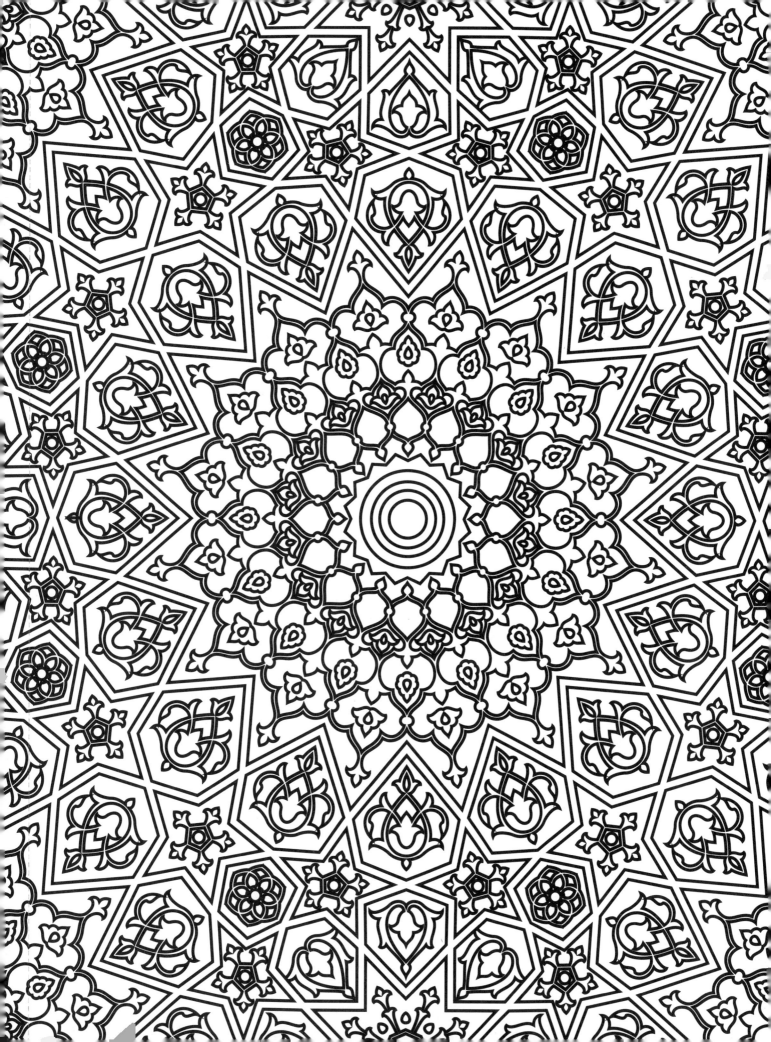

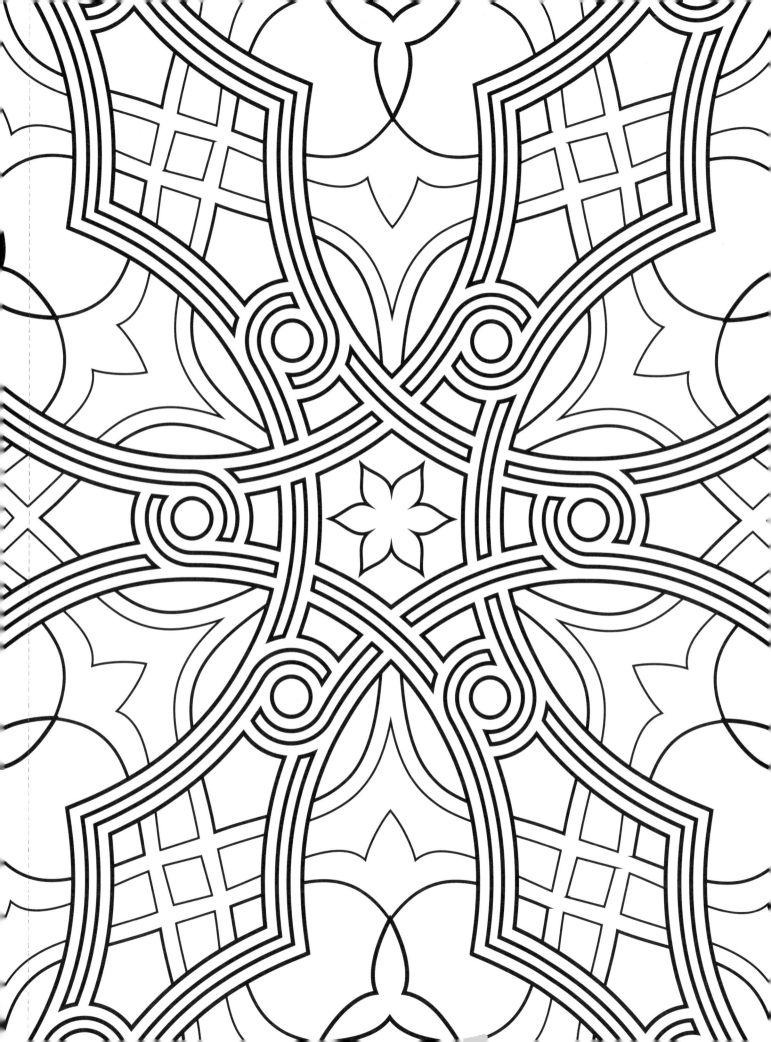

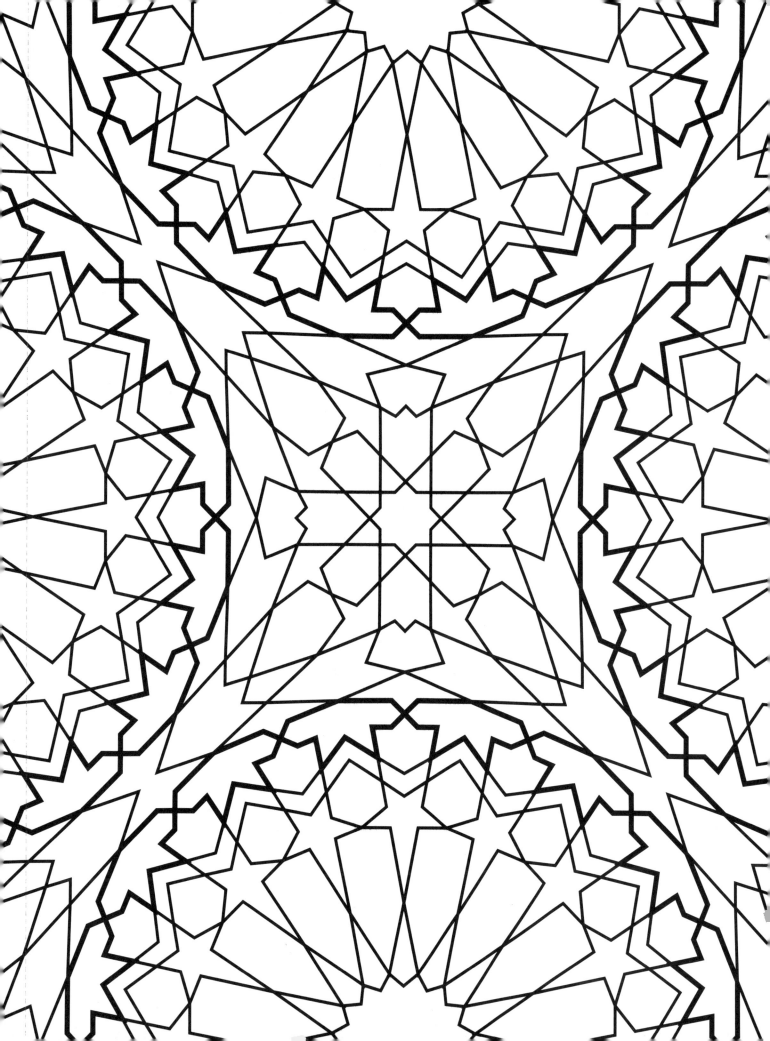

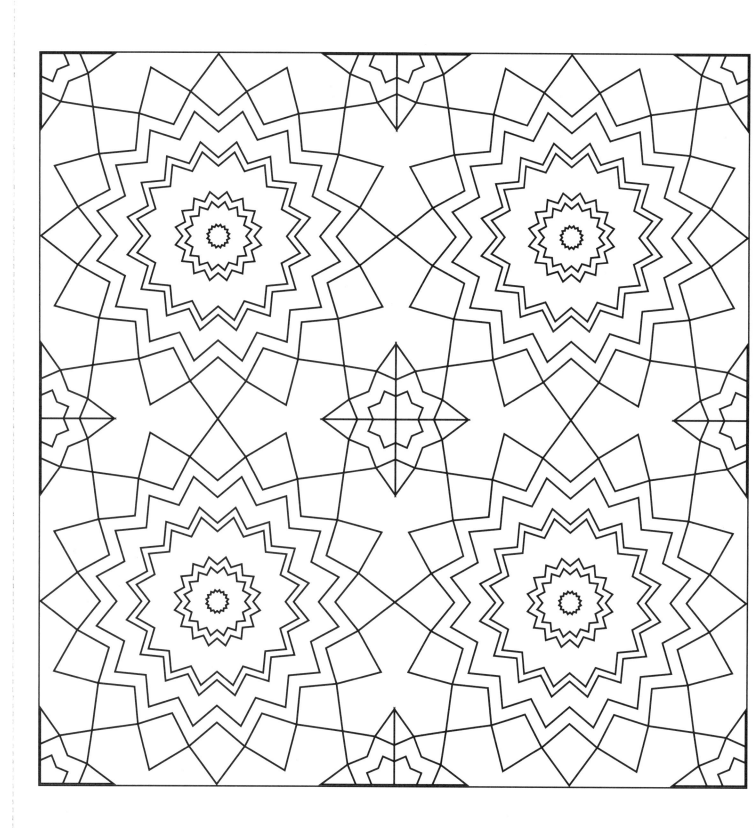

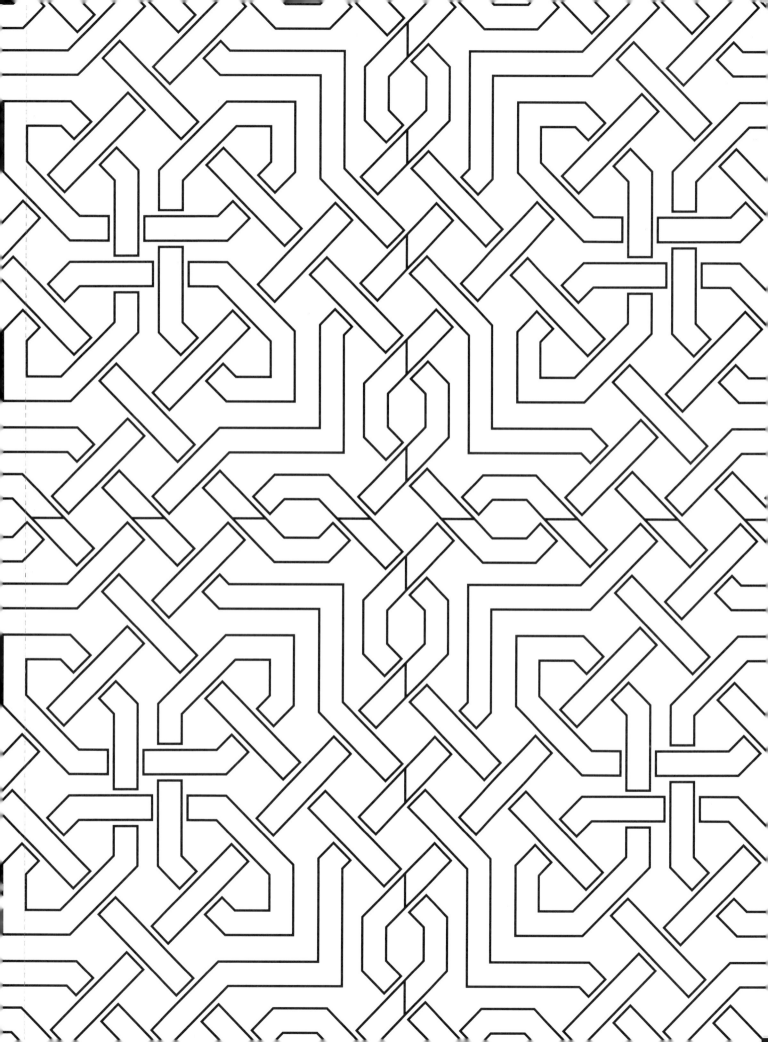

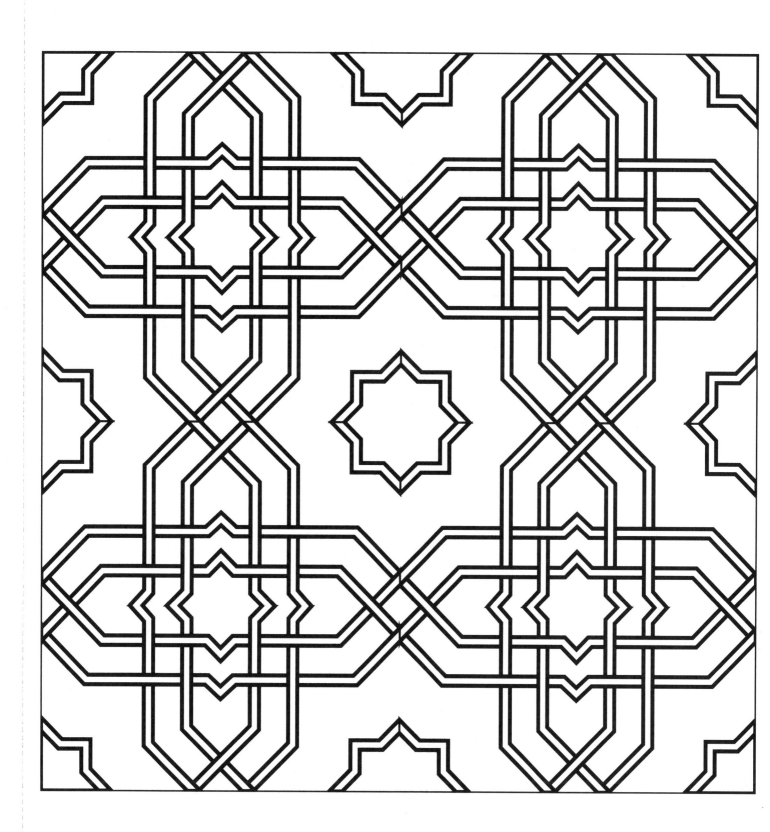

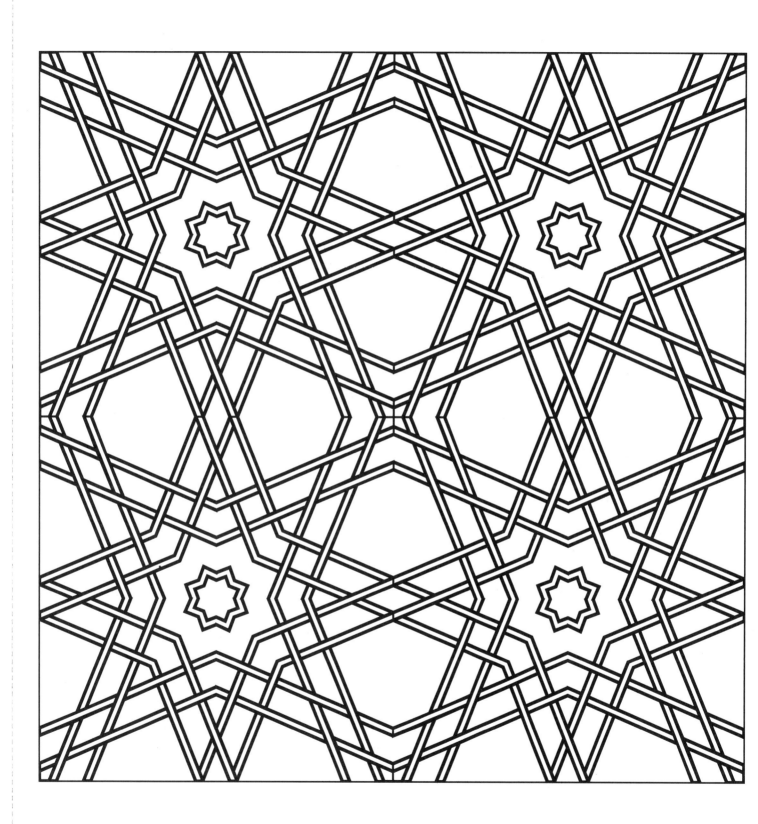

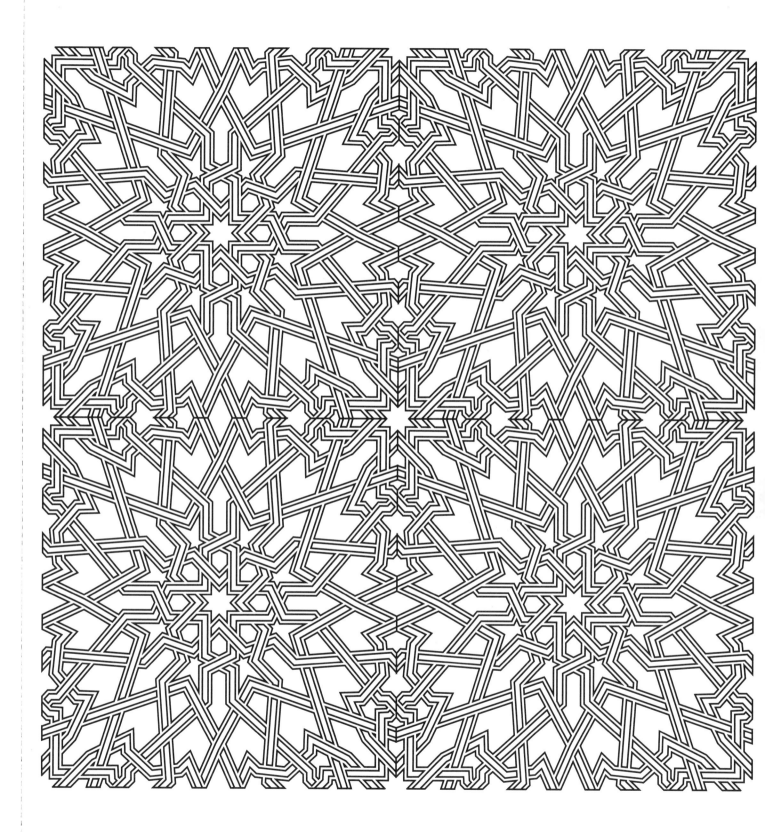

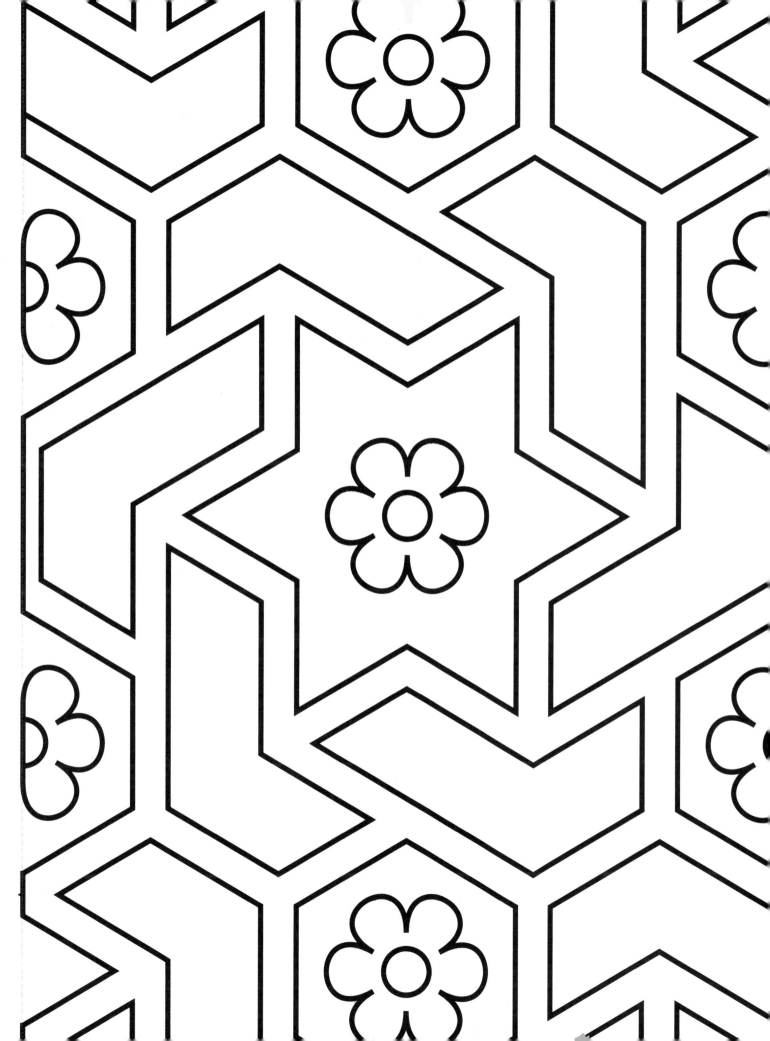

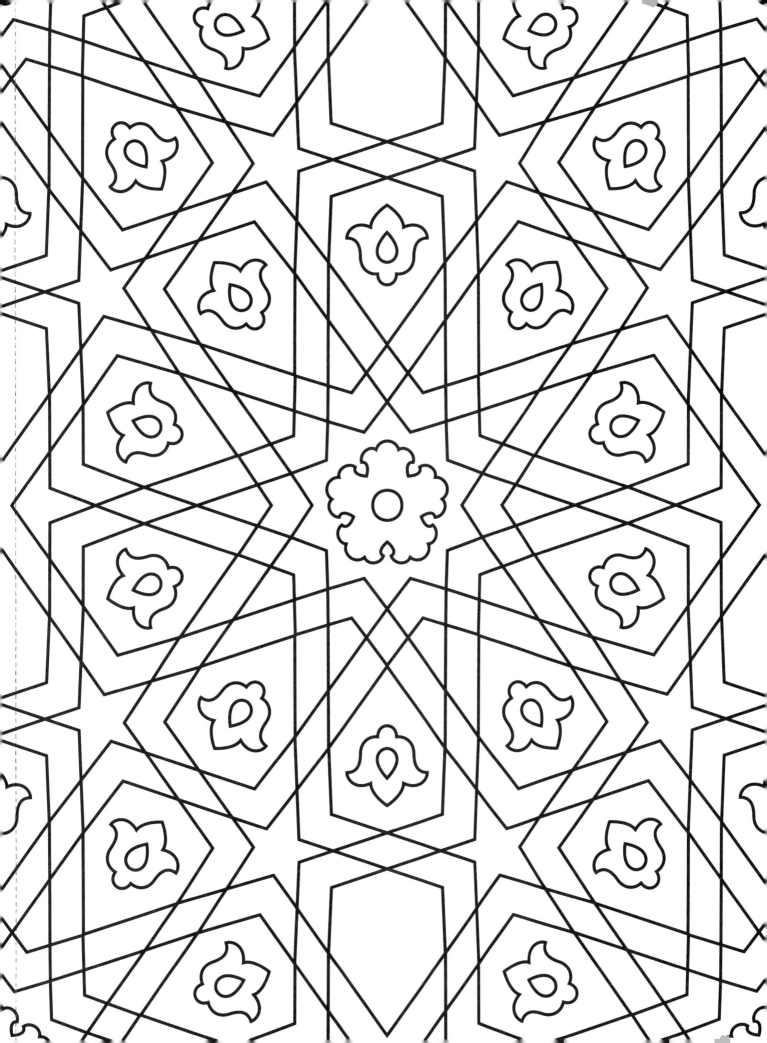

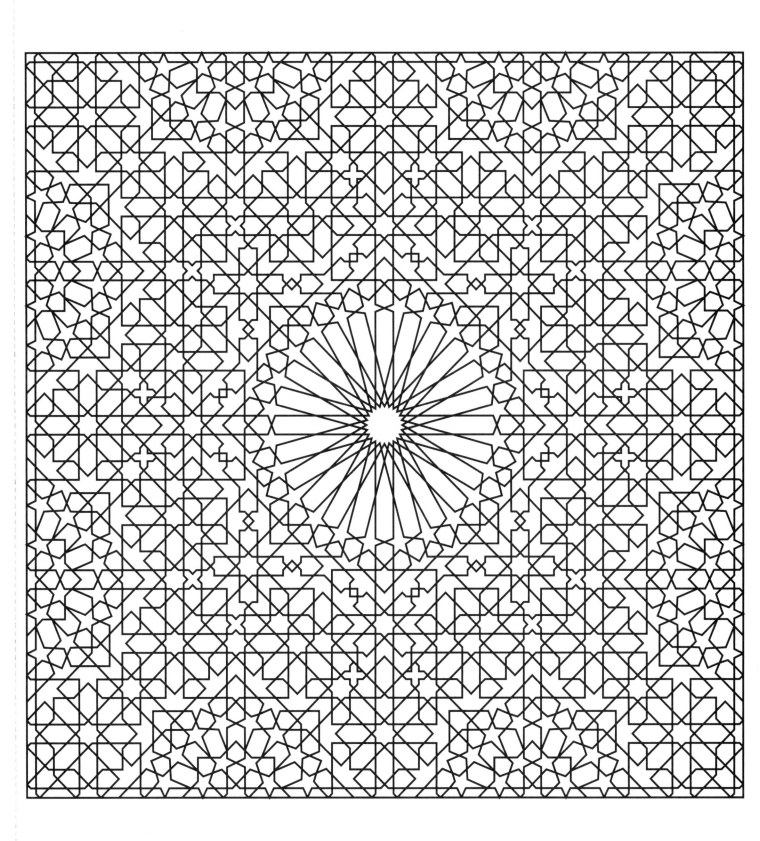

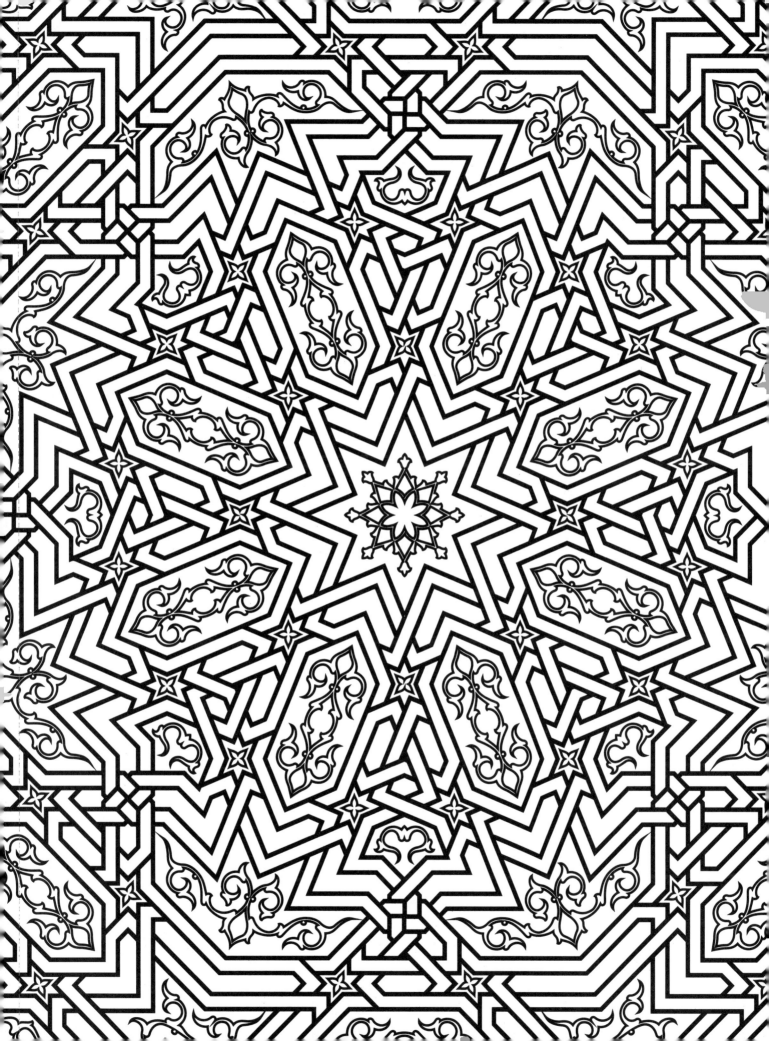

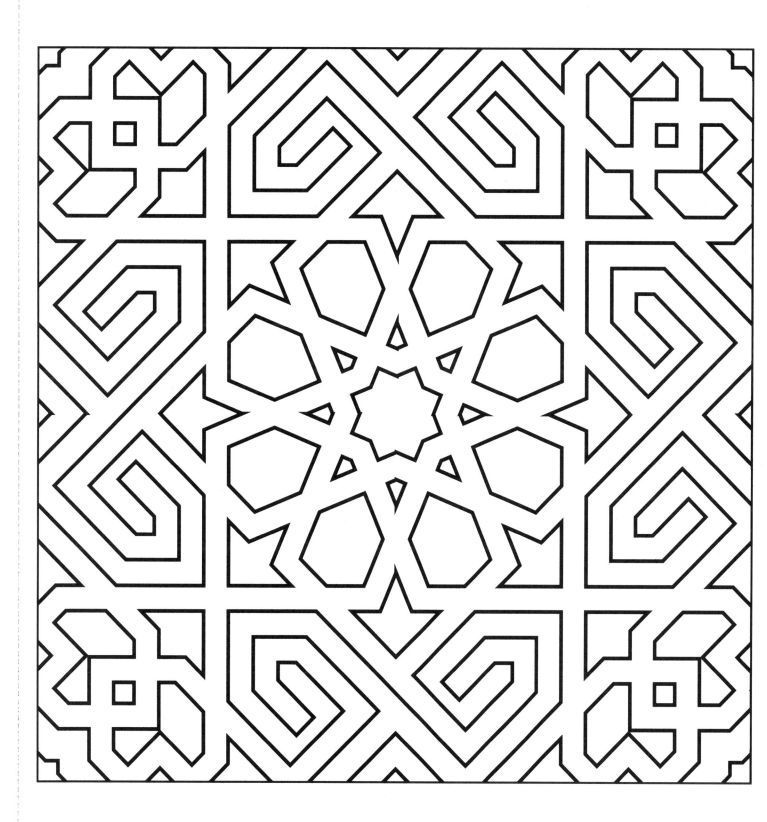

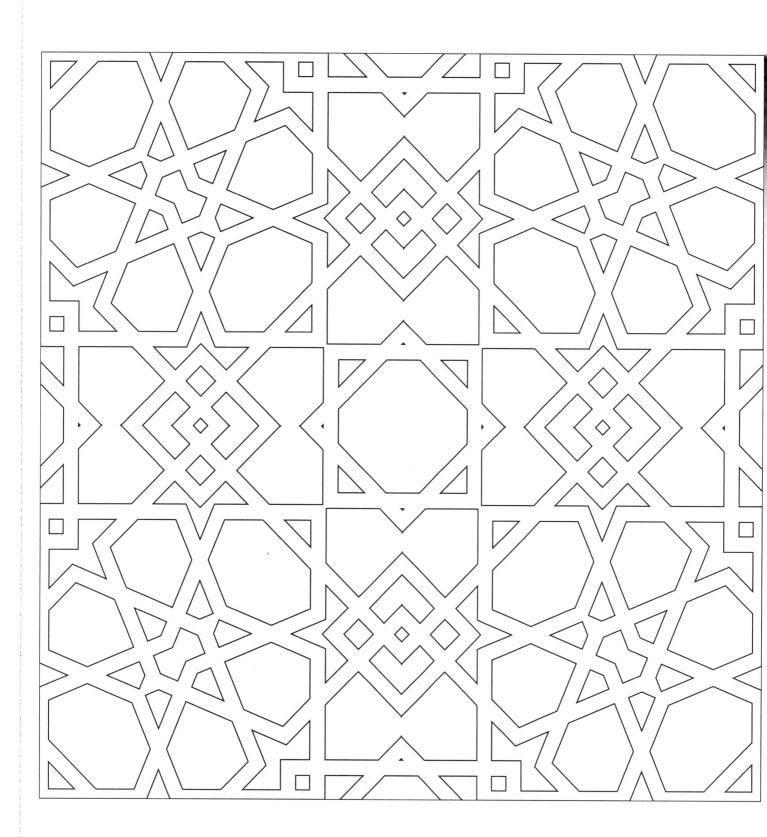

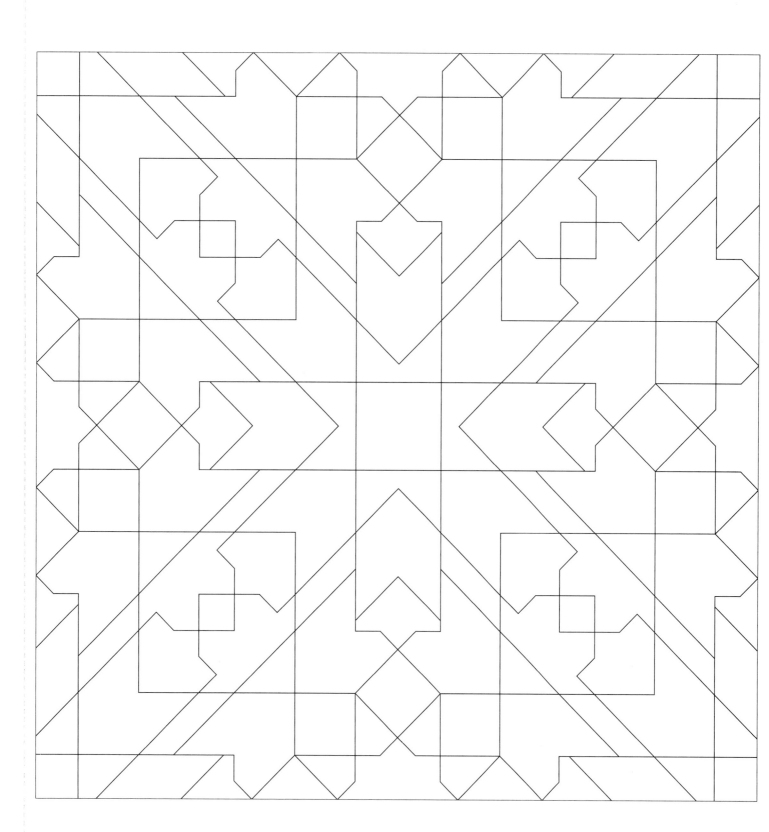

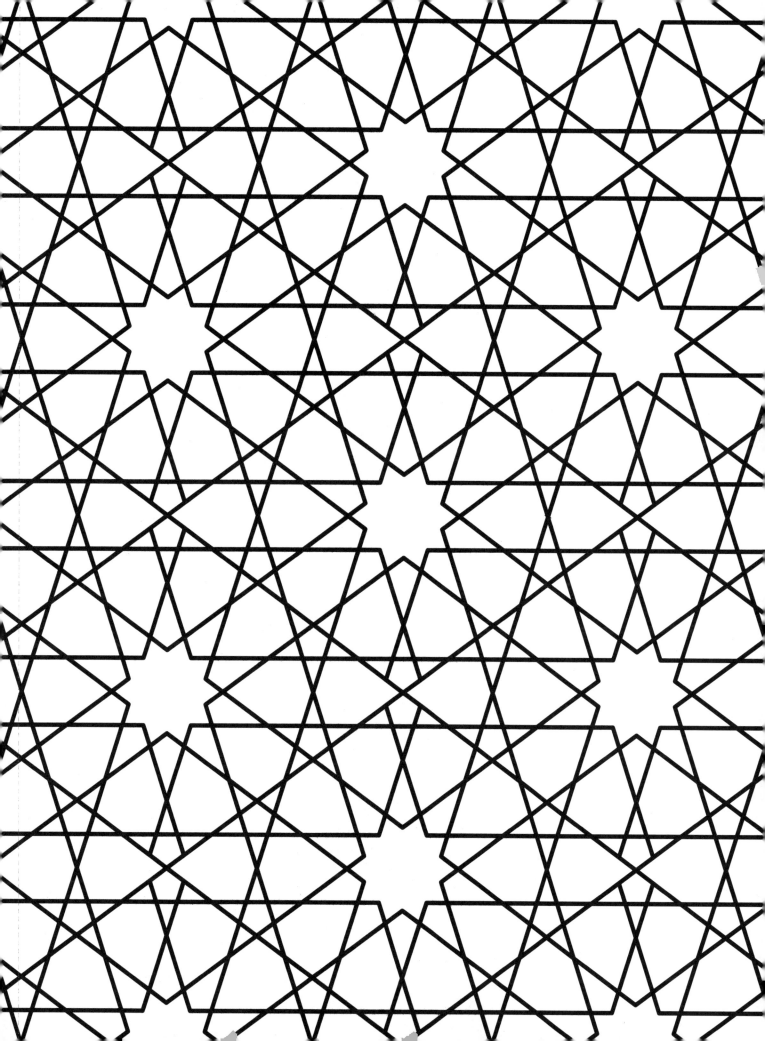

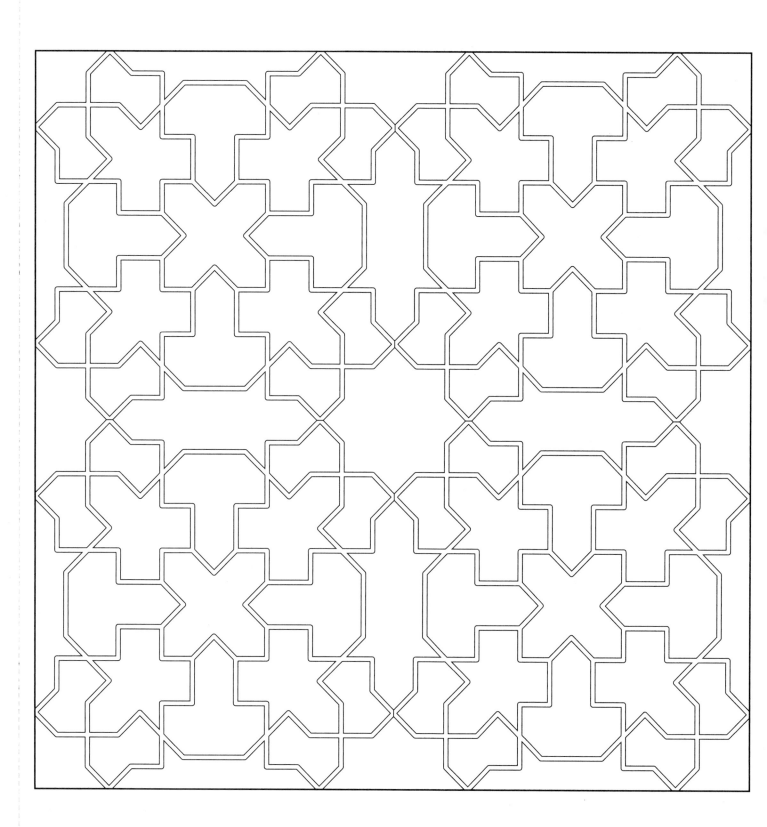

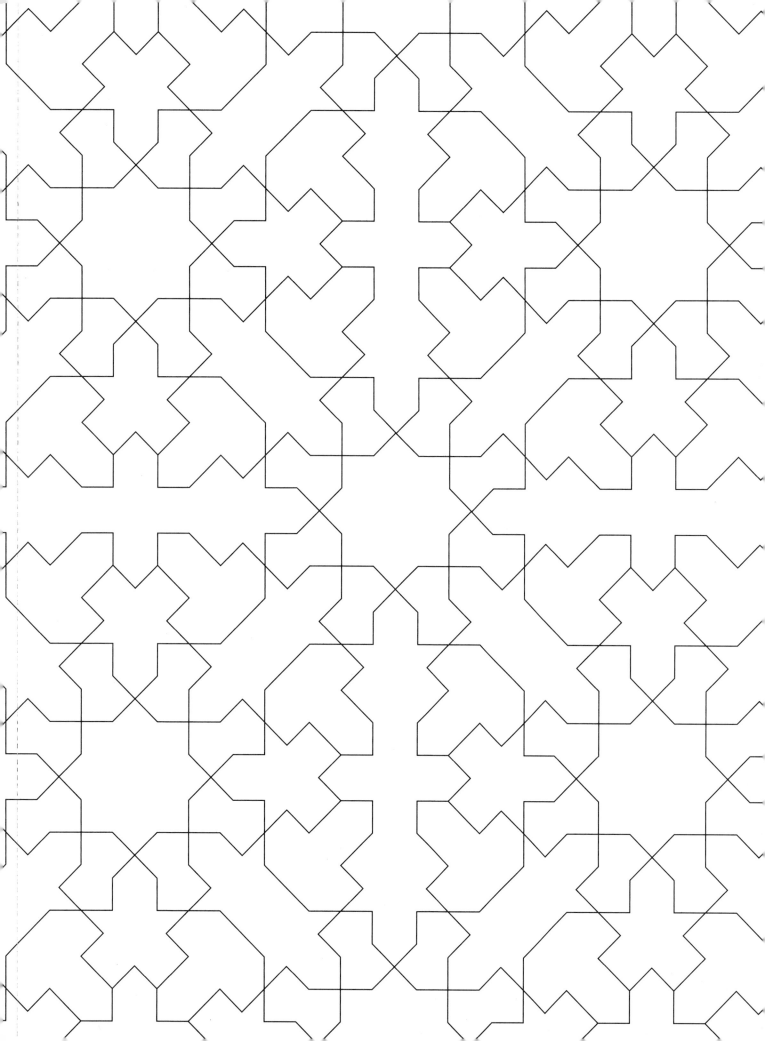

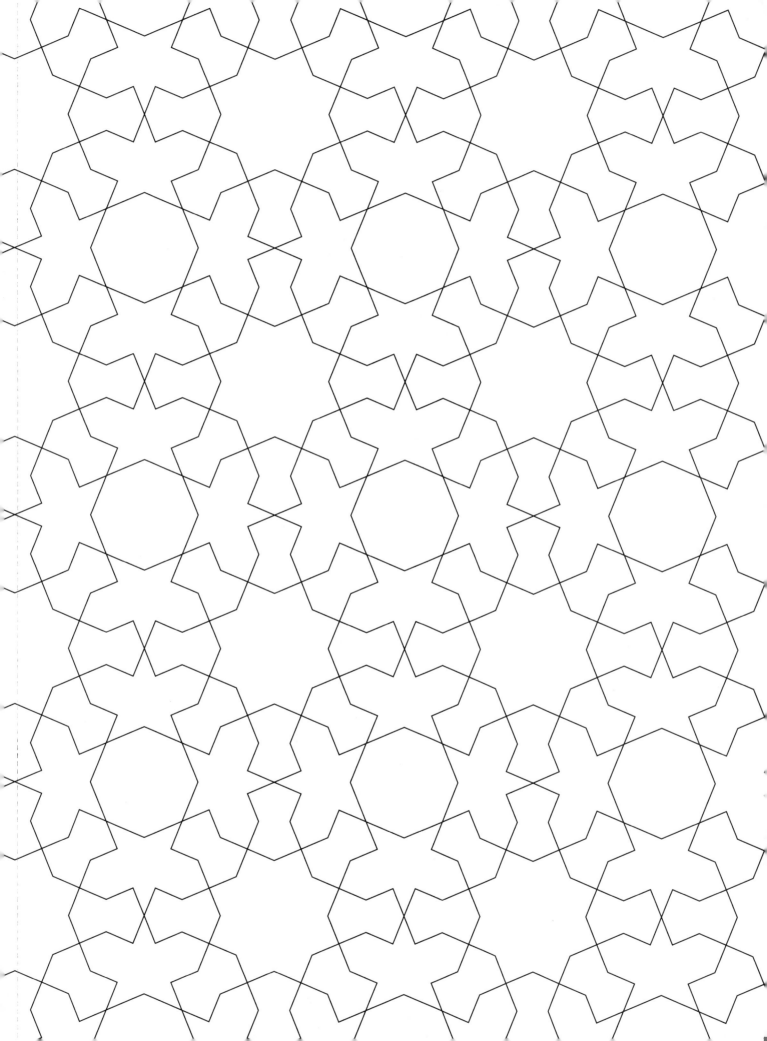

Color Bars

Use these bars to test your coloring medium and palette. Don't be afraid to try unique color combinations!

Color Bars

Color Bars

Also Available from Skyhorse Publishing

Creative Stress Relieving Adult Coloring Book Series

Art Nouveau: Coloring for Artists
Art Nouveau: Coloring for Everyone
Butterfly Gardens: Coloring for Everyone
Curious Cats and Kittens: Coloring for Artists
Curious Cats and Kittens: Coloring for Everyone
Exotic Chickens: Coloring for Everyone
Mandalas: Coloring for Artists
Mandalas: Coloring for Everyone
Mehndi: Coloring for Artists
Mehndi: Coloring for Everyone
Moroccan Motifs: Coloring for Artists
Nature's Wonders: Coloring for Everyone
Nirvana: Coloring for Artists
Nirvana: Coloring for Everyone
Paisleys: Coloring for Artists
Paisleys: Coloring for Everyone
Stained Glass: Coloring for Artists
Tapestries, Fabrics, and Quilts: Coloring for Artists
Tapestries, Fabrics, and Quilts: Coloring for Everyone
Whimsical Designs: Coloring for Artists
Whimsical Designs: Coloring for Everyone
Whimsical Woodland Creatures: Coloring for Artists
Whimsical Woodland Creatures: Coloring for Everyone
Zen Patterns and Designs: Coloring for Artists
Zen Patterns and Designs: Coloring for Everyone

New York Times Bestselling Artists' Adult Coloring Book Series

Marty Noble's Sugar Skulls
Marty Noble's Peaceful World
Marjorie Sarnat's Fanciful Fashions
Marjorie Sarnat's Pampered Pets

The Peaceful Adult Coloring Book Series

Adult Coloring Book: Be Inspired
Adult Coloring Book: De-Stress
Adult Coloring Book: Keep Calm
Adult Coloring Book: Relax

Portable Coloring for Creative Adults

Calming Patterns: Portable Coloring for Creative Adults
Flying Wonders: Portable Coloring for Creative Adults
Natural Wonders: Portable Coloring for Creative Adults
Sea Life: Portable Coloring for Creative Adults